Glorious Scenes to Color
Comfort and Joy
COLORING BOOK

Good Books

Good Books books may be purchased in bulk at special discounts for sales promotion, corporate gifts, fund-raising, or educational purposes. Special editions can also be created to specifications. For details, contact the Special Sales Department, Good Books, 307 West 36th Street, 11th Floor, New York, NY 10018 or info@skyhorsepublishing.com.

Good Books is an imprint of Skyhorse Publishing, Inc.®, a Delaware corporation.

Visit our website at www.goodbooks.com.

10 9 8 7 6 5 4 3 2 1

Print ISBN: 978-1-68099-200-7

Cover and interior artwork by Ted Menten

Printed in the United States of America

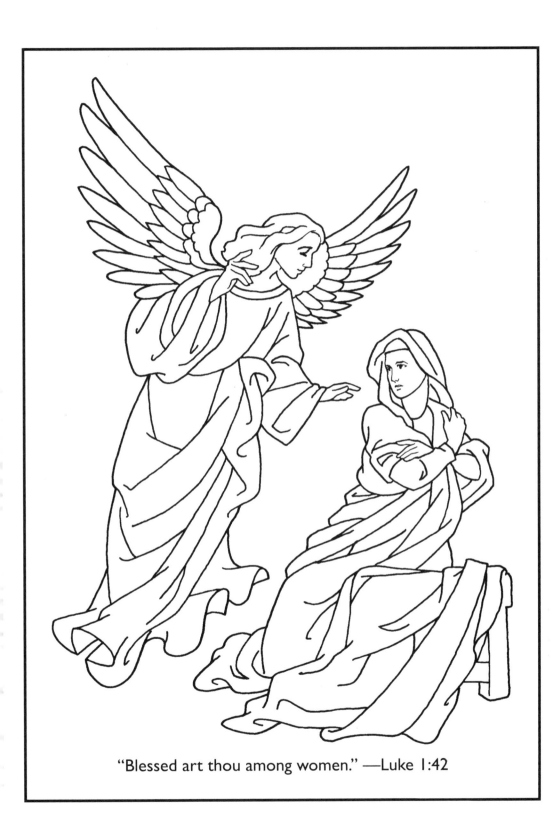

"Blessed art thou among women." —Luke 1:42

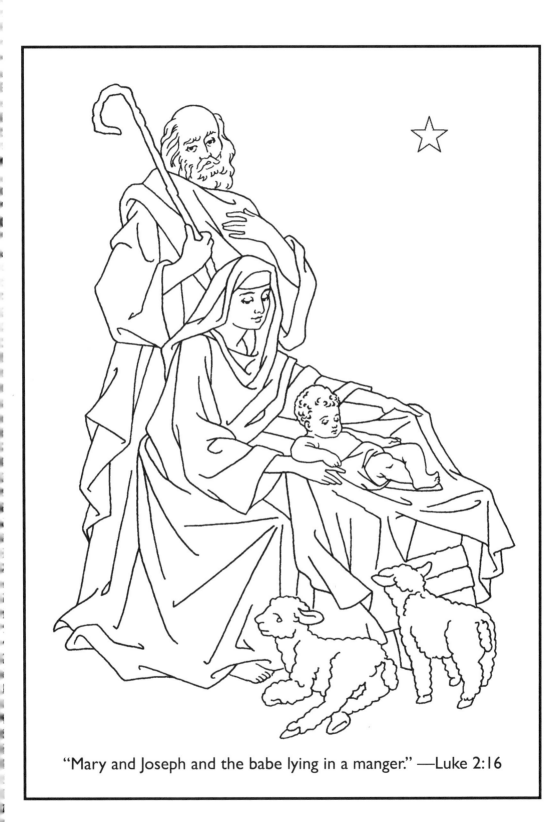

"Mary and Joseph and the babe lying in a manger." —Luke 2:16

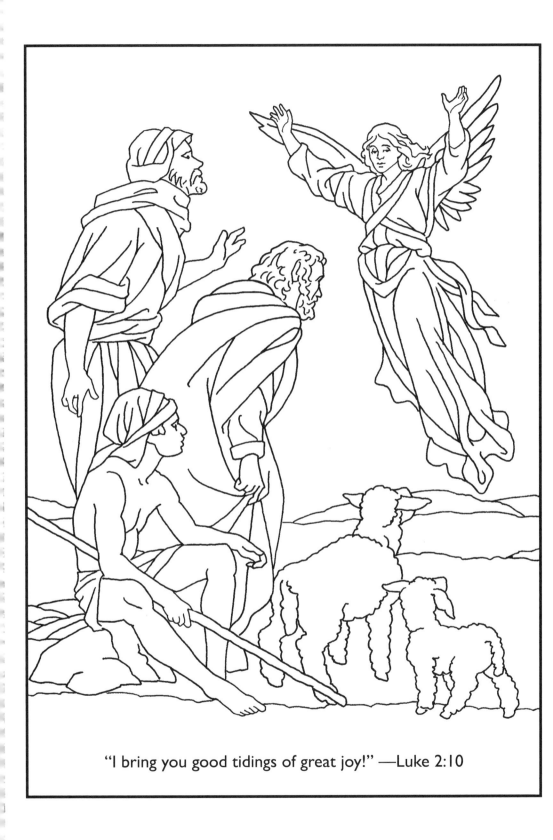

"I bring you good tidings of great joy!" —Luke 2:10

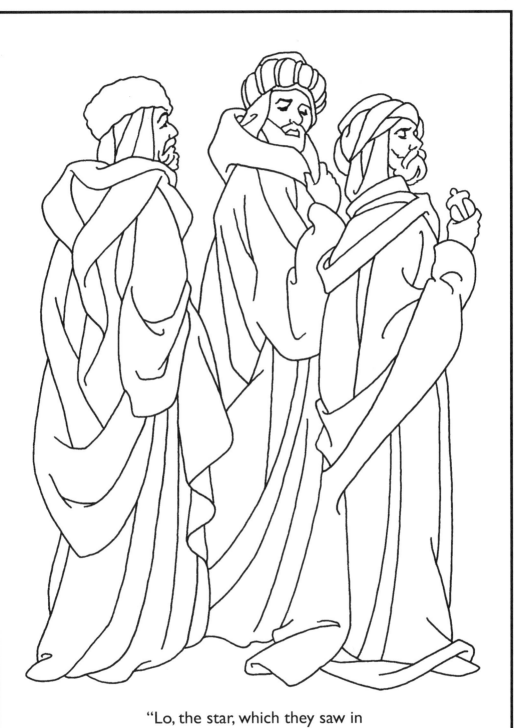

"Lo, the star, which they saw in
the east, went before them." —Matthew 2:9

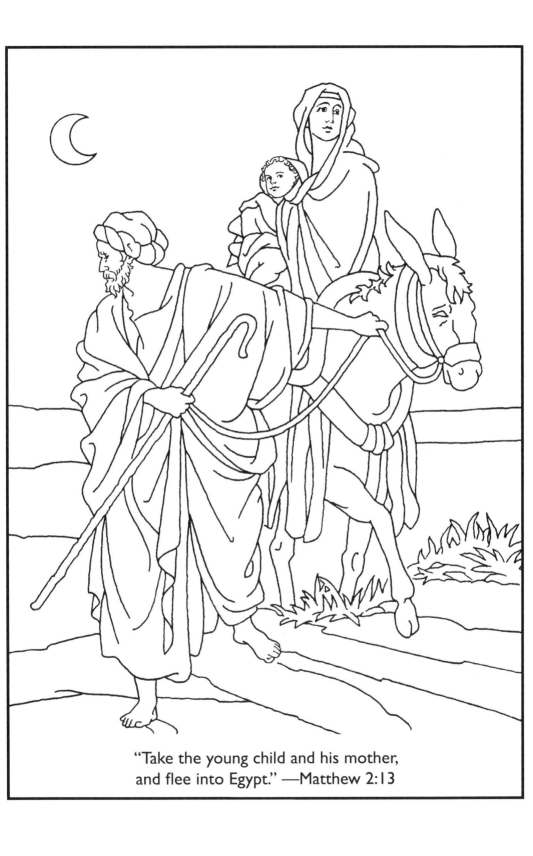

"Take the young child and his mother,
and flee into Egypt." —Matthew 2:13

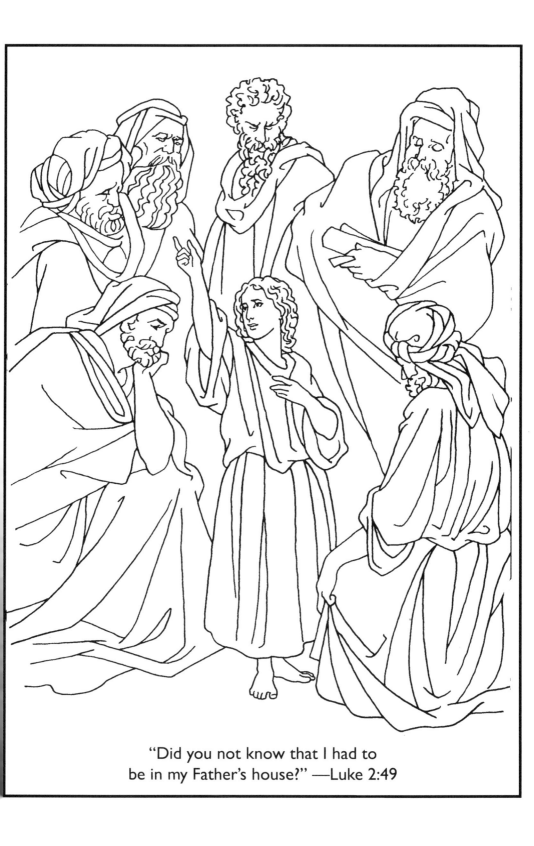

"Did you not know that I had to
be in my Father's house?" —Luke 2:49

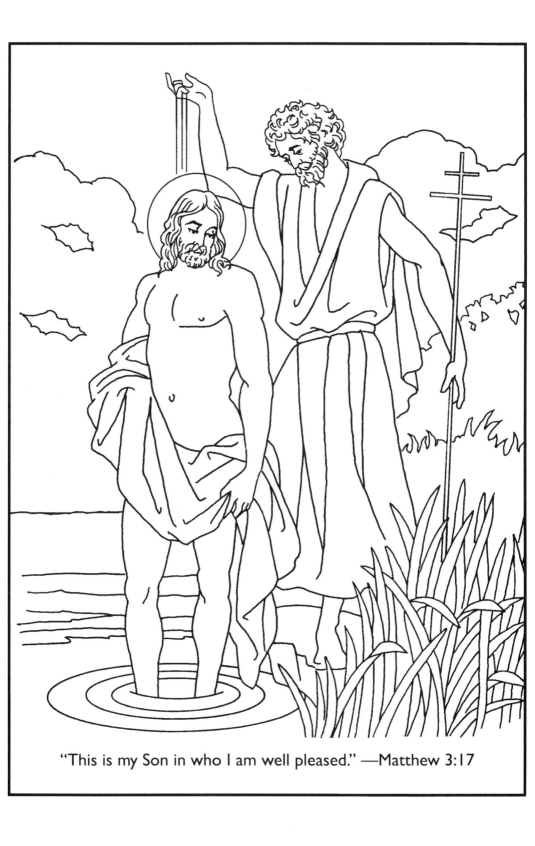

"This is my Son in who I am well pleased." —Matthew 3:17

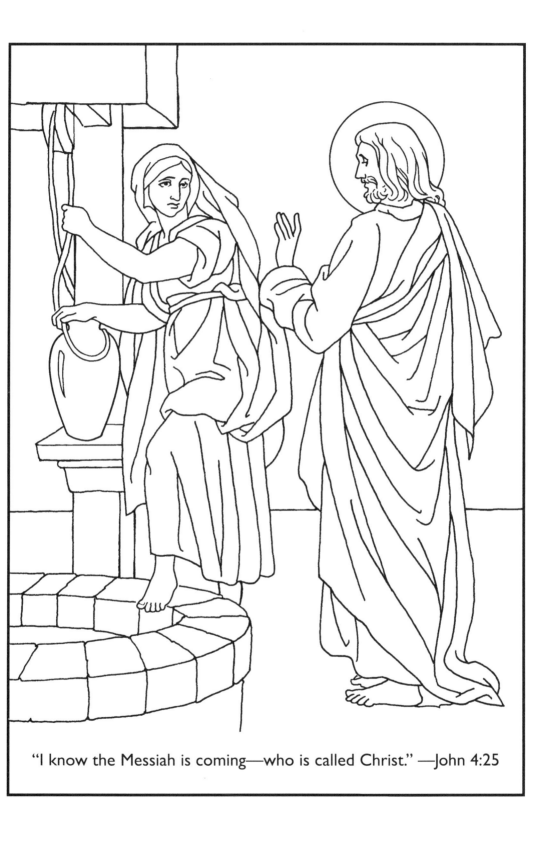

"I know the Messiah is coming—who is called Christ." —John 4:25

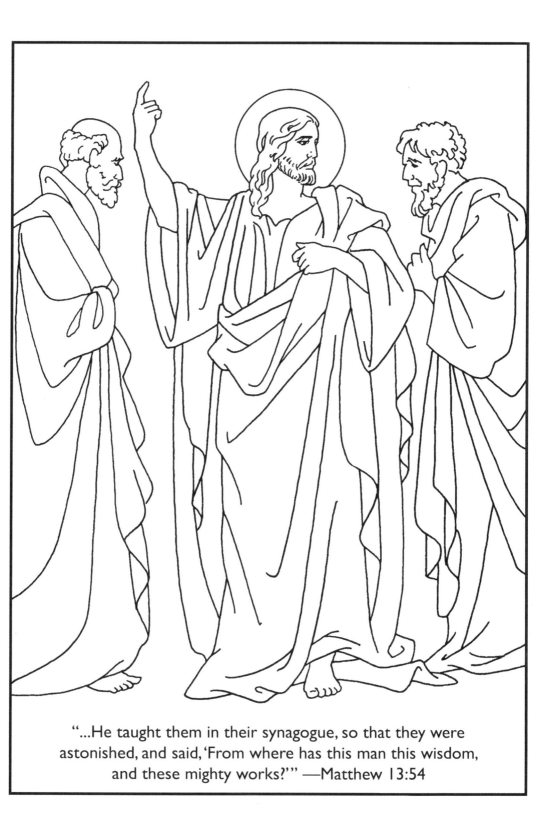

"...He taught them in their synagogue, so that they were astonished, and said, 'From where has this man this wisdom, and these mighty works?'" —Matthew 13:54

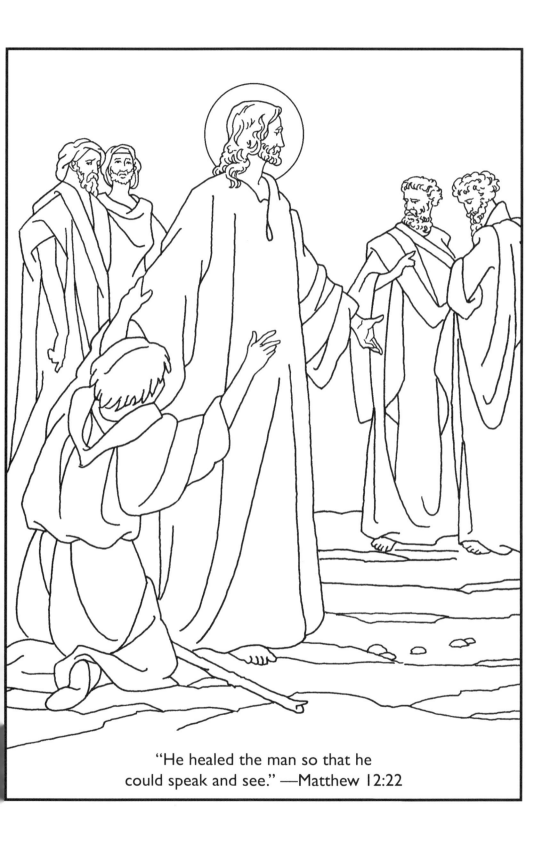

"He healed the man so that he
could speak and see." —Matthew 12:22

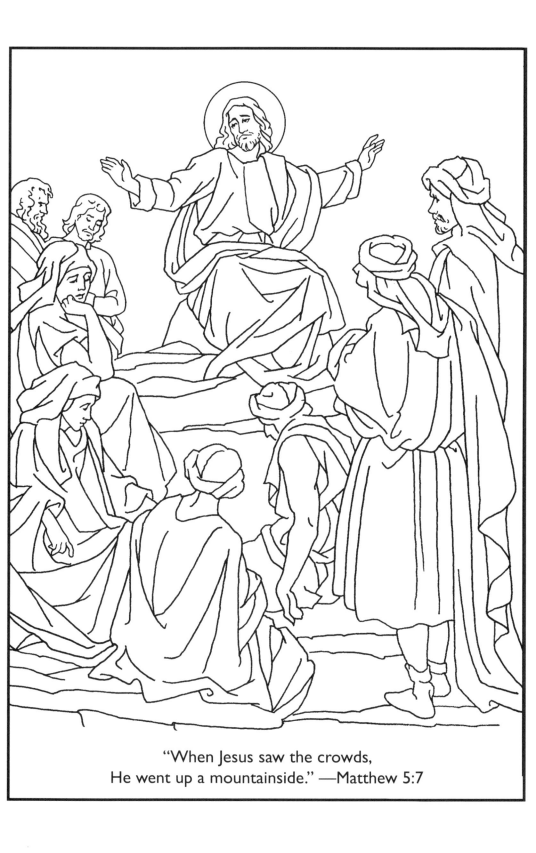

"When Jesus saw the crowds,
He went up a mountainside." —Matthew 5:7

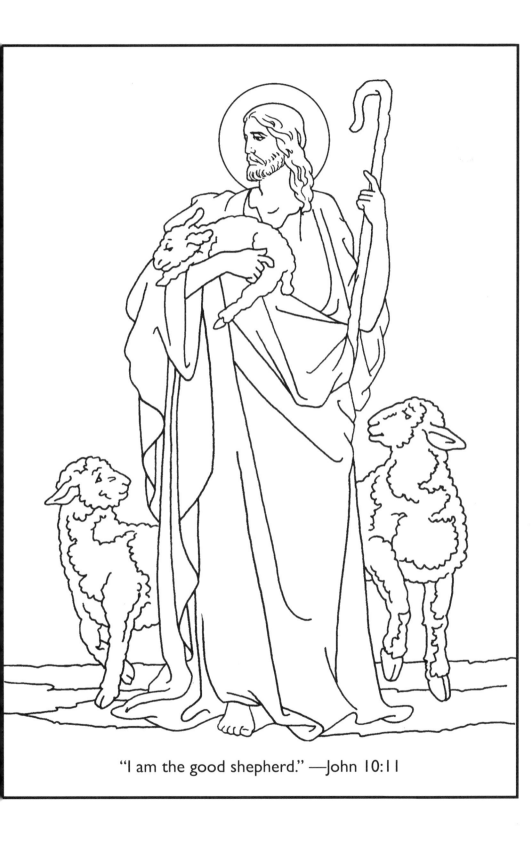

"I am the good shepherd." —John 10:11

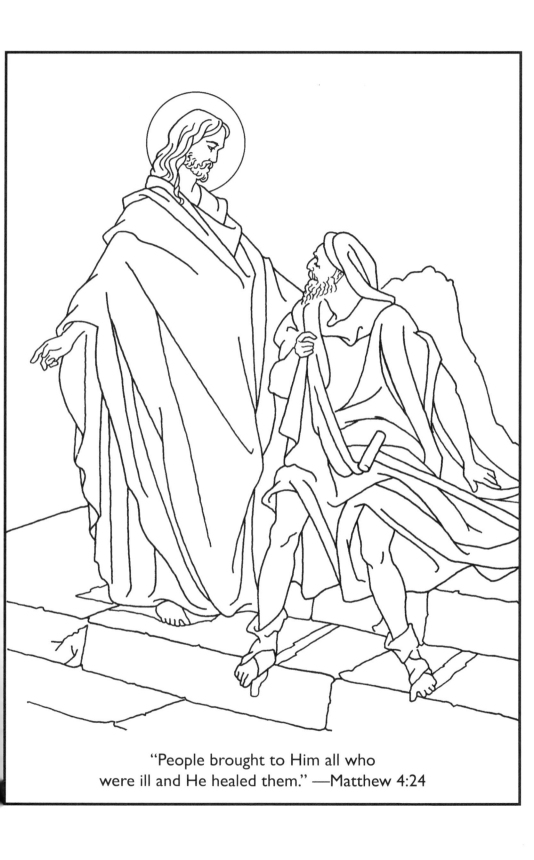

"People brought to Him all who
were ill and He healed them." —Matthew 4:24

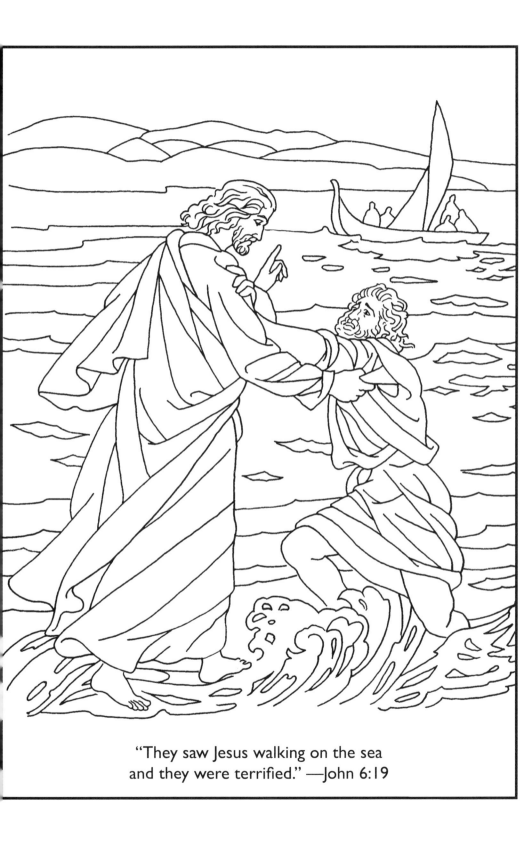

"They saw Jesus walking on the sea
and they were terrified." —John 6:19

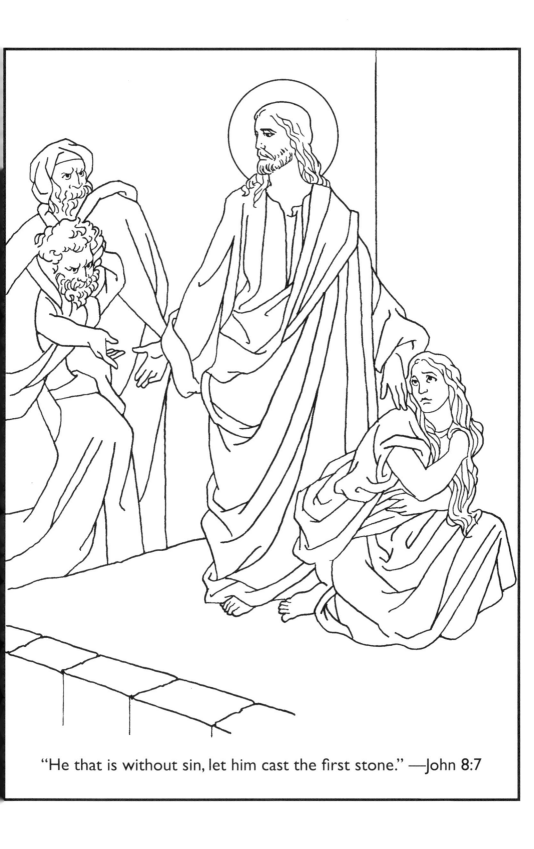

"He that is without sin, let him cast the first stone." —John 8:7

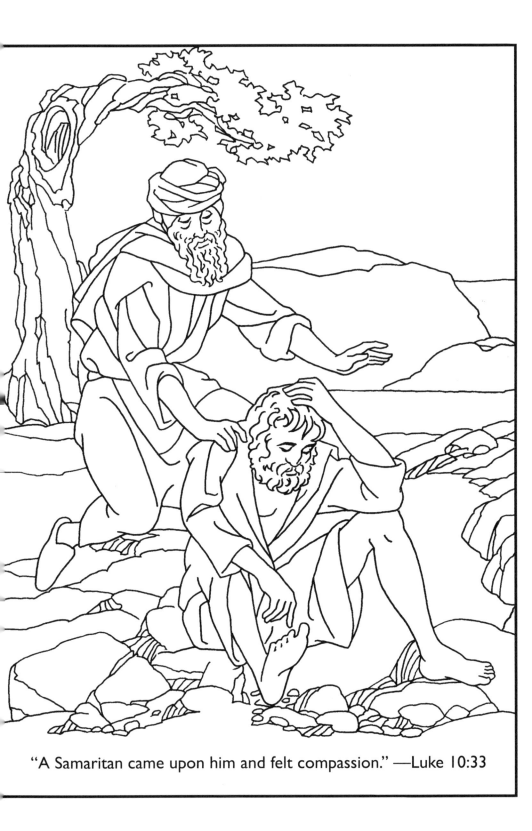

"A Samaritan came upon him and felt compassion." —Luke 10:33

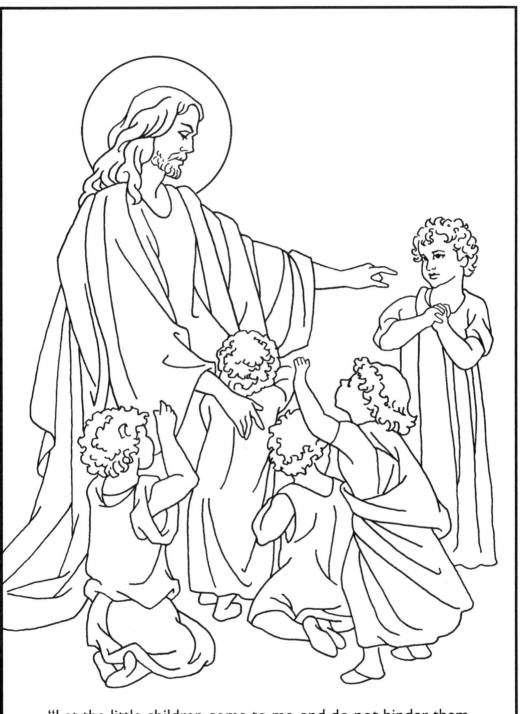

"Let the little children come to me, and do not hinder them,
for the kingdom of God belongs to such as these." —Mark 10:14

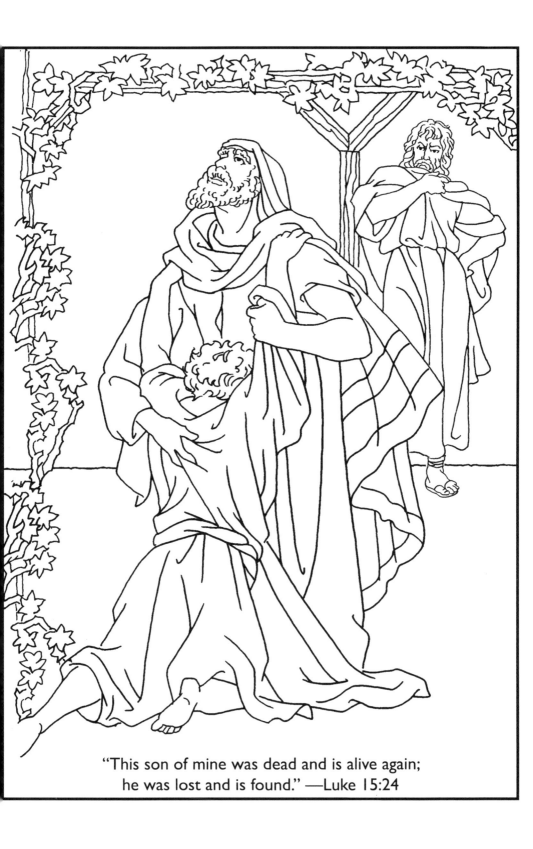

"This son of mine was dead and is alive again;
he was lost and is found." —Luke 15:24

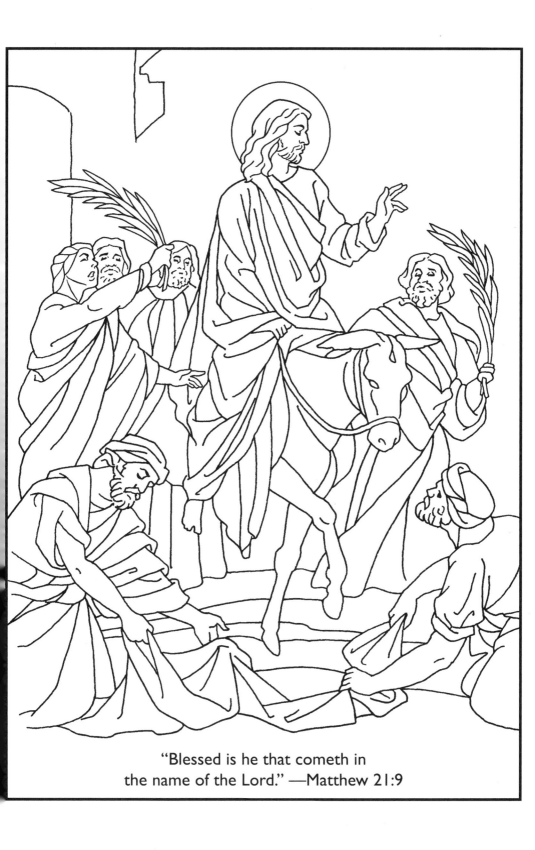

"Blessed is he that cometh in
the name of the Lord." —Matthew 21:9

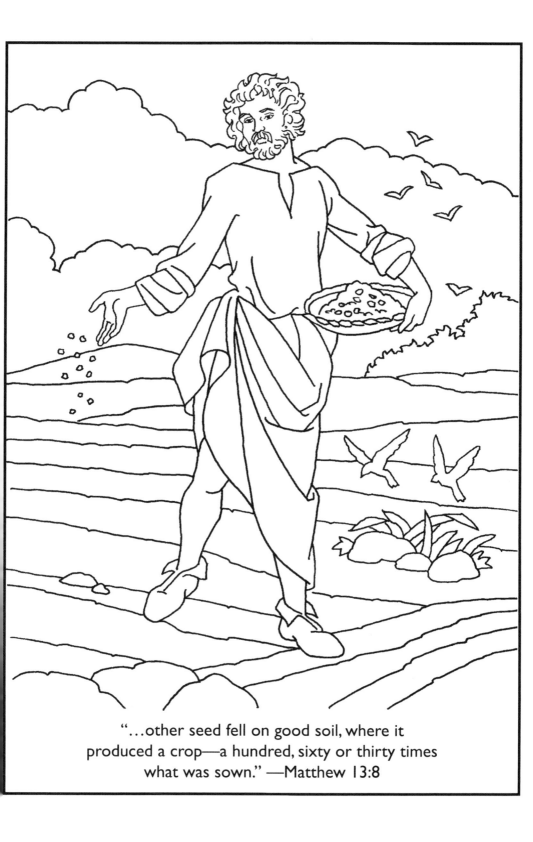

"...other seed fell on good soil, where it
produced a crop—a hundred, sixty or thirty times
what was sown." —Matthew 13:8

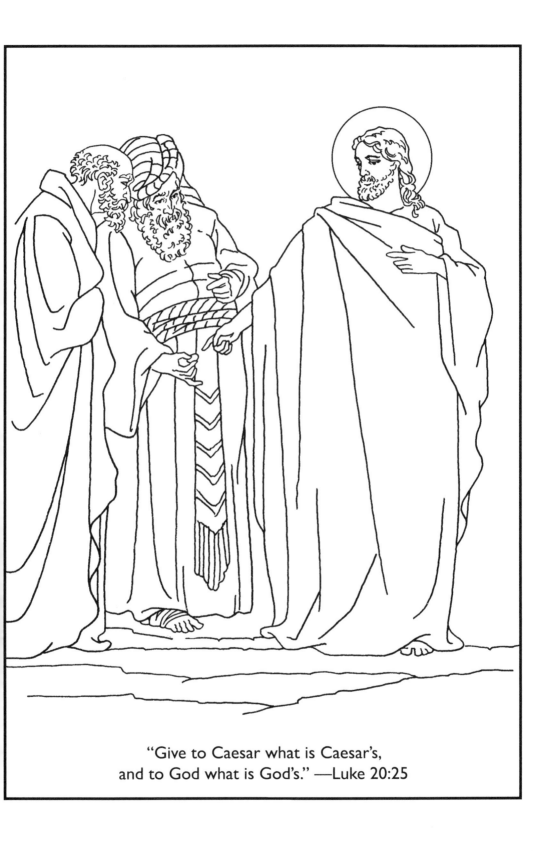

"Give to Caesar what is Caesar's,
and to God what is God's." —Luke 20:25

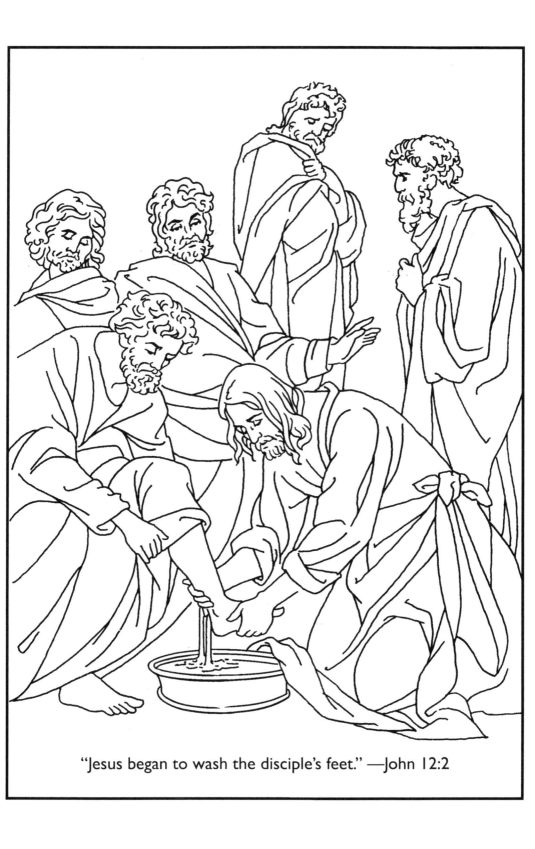

"Jesus began to wash the disciple's feet." —John 12:2

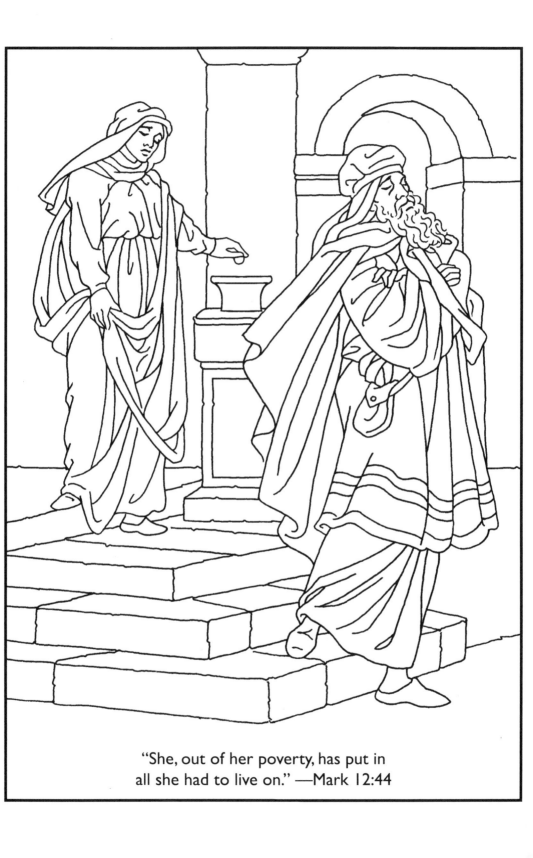

"She, out of her poverty, has put in
all she had to live on." —Mark 12:44

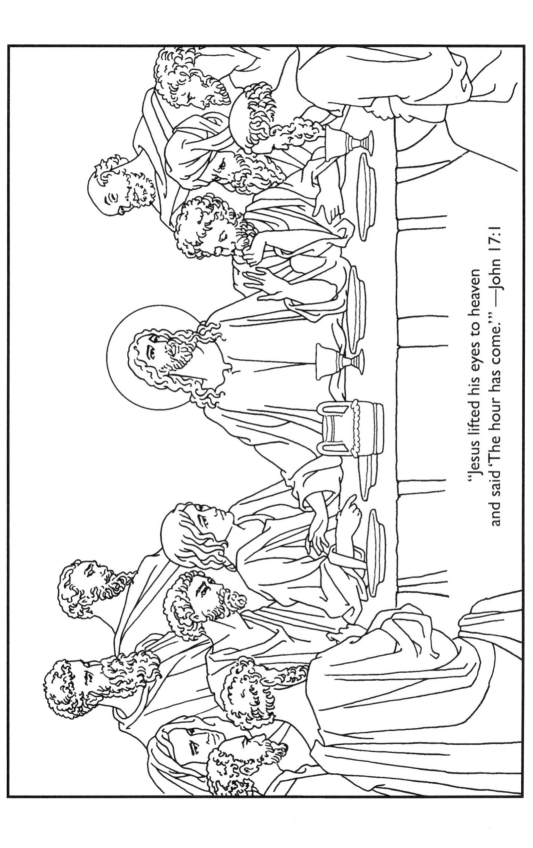

"Jesus lifted his eyes to heaven and said 'The hour has come.'" —John 17:1

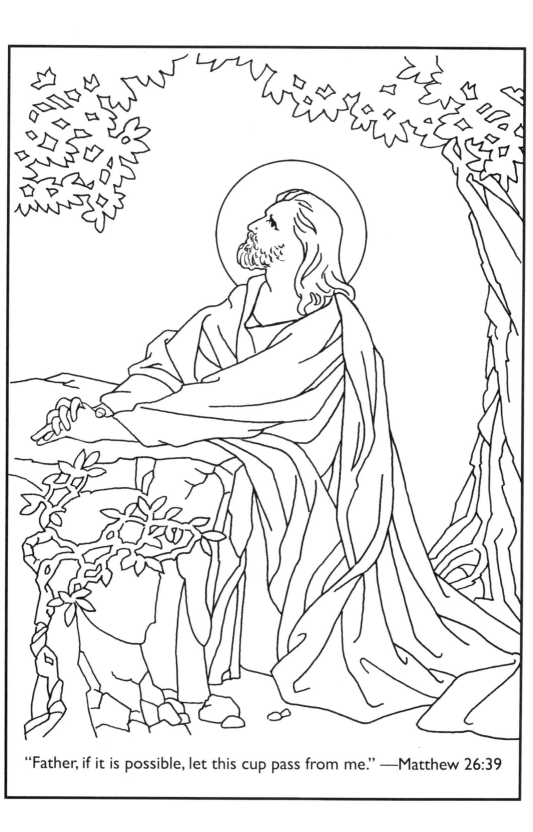

"Father, if it is possible, let this cup pass from me." —Matthew 26:39

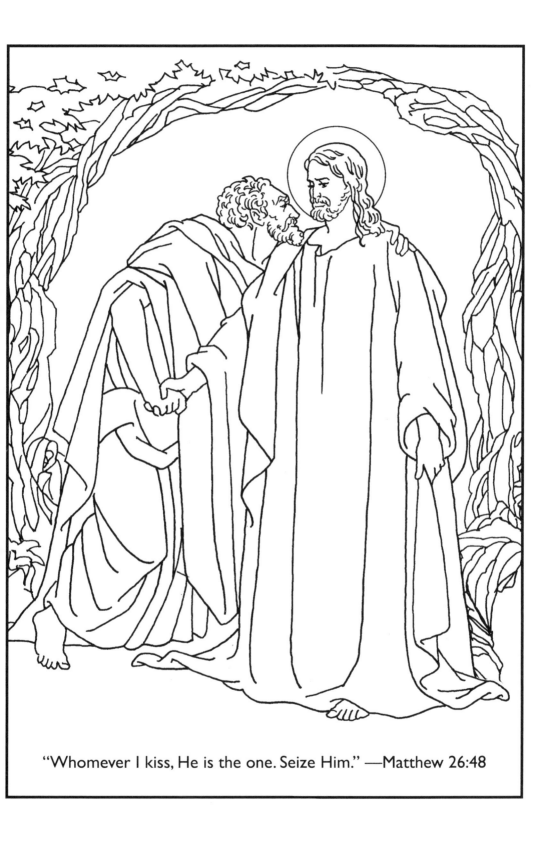

"Whomever I kiss, He is the one. Seize Him." —Matthew 26:48

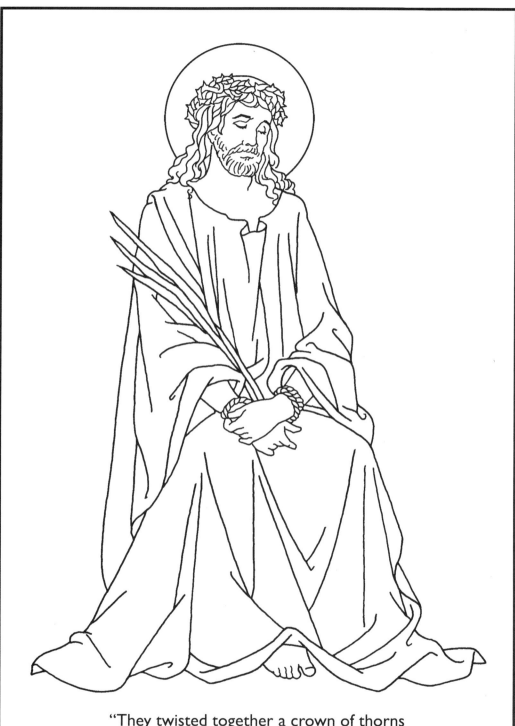

"They twisted together a crown of thorns and put it on his head." —Matthew 27:29

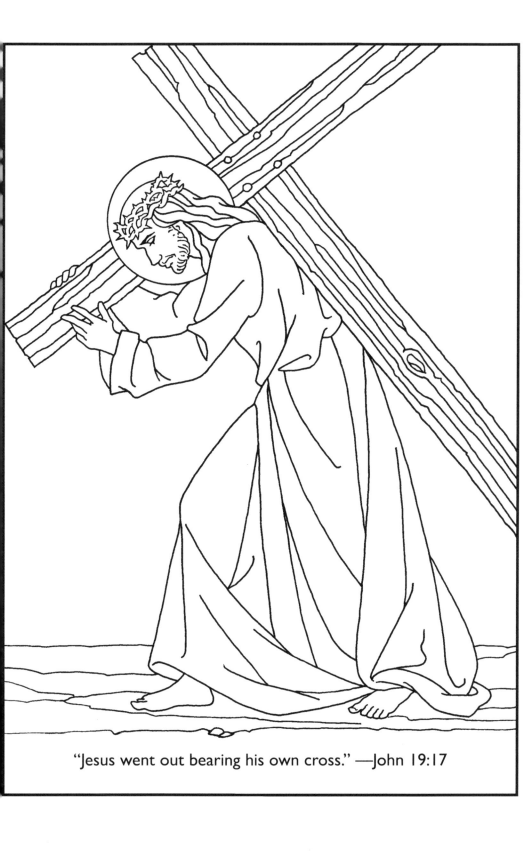

"Jesus went out bearing his own cross." —John 19:17

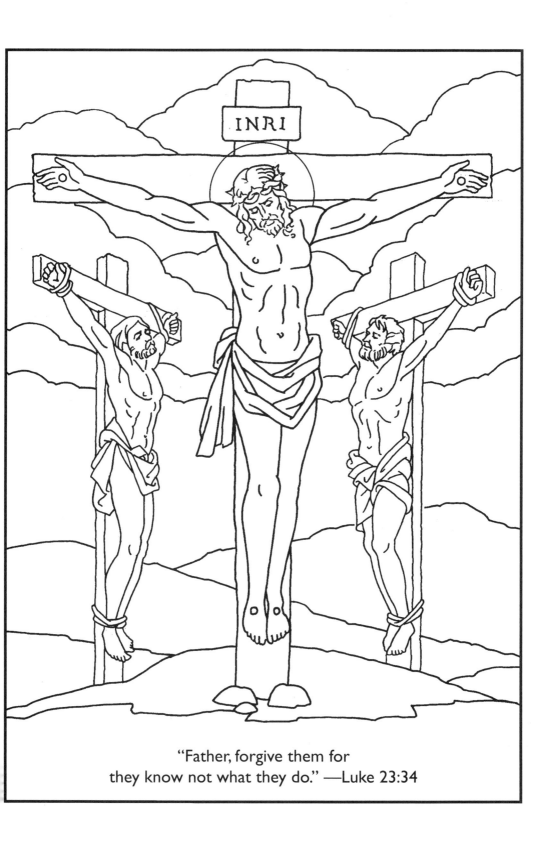

"Father, forgive them for
they know not what they do." —Luke 23:34

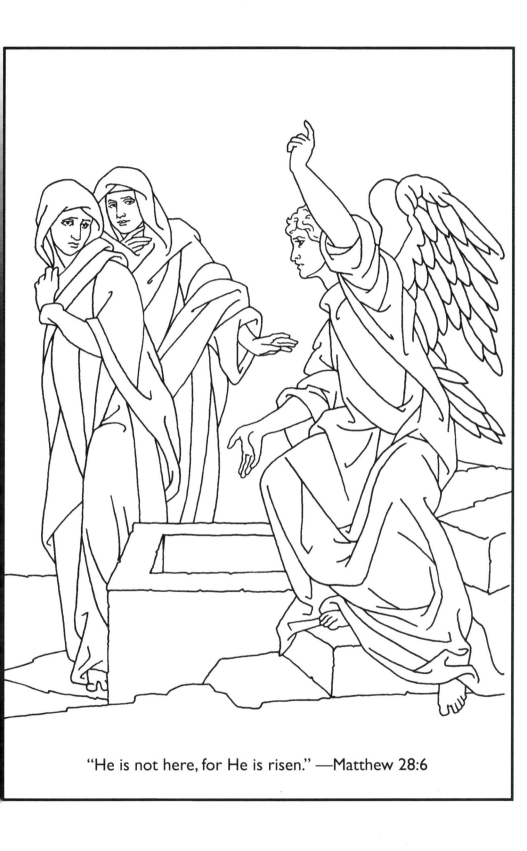

"He is not here, for He is risen." —Matthew 28:6

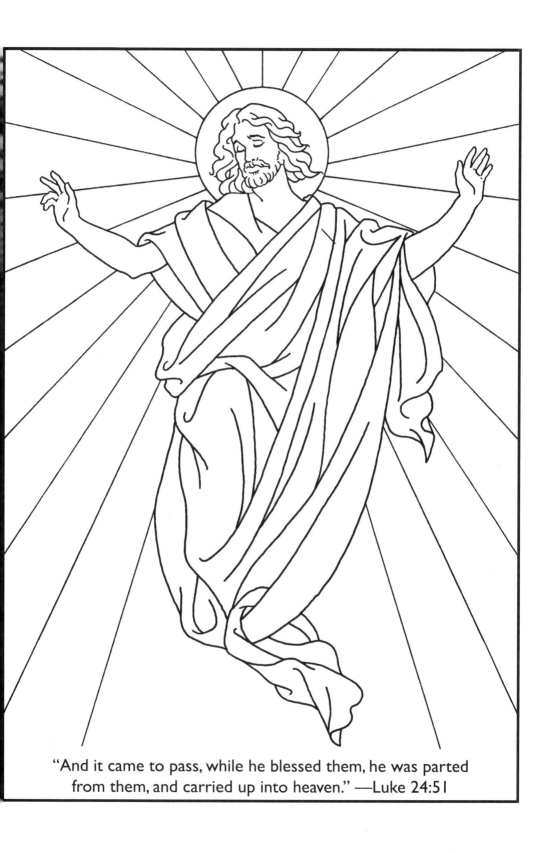

"And it came to pass, while he blessed them, he was parted from them, and carried up into heaven." —Luke 24:51